A Practical Guide to

Body Art

Techniques and materials
explained step-by-step

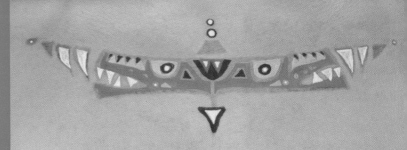

Over 50 design ideas to choose from.
Patterns and ideas from ancient, Celtic,
Mexican, North American Indian and
Southern Pacific cultures

Hilary Hammond

Acknowledgments:

A very special thank you to BODY ART Supply for their help and for supplying henna, temporary tattoos and accessories for use in this publication.

Special thanks to the students and staff of Gateway College in Leicester.
Models: James Baker, Carmen Jones, Natasha Patel, Dominic Zaman, Gabi Beswic, Mathew Peers, Vashali Parmar, Adam Ray, Lindsay Findlay, Olga Dubrova, Danielle Baker, Tim Dodd, Farhana Kadri
Henna Artists: Rubeena Kadri, Daryl Pascall, Rebecca Hubert, Alex Parkin

This edition first published in the United Kingdom in 2000 by Caxton Editions
20 Bloomsbury Street
London WC1B 3QA
a member of the Caxton Publishing Group

Designed and Produced for Caxton Editions by Open Door Limited
80 High Street, Colsterworth, Lincolnshire, NG33 5JA
Photography: Chris Allen, Forum Advertising
Colour separation: GA Graphics Stamford

Title: Body Art
ISBN: 1-84067-234-X

Picture credits
Werner Forman Archive: p. 7, 10 (British Museum, London),
11 (Egyptian Museum, Berlin), 12 (private collection),
14-15 (National Museum of Ireland), 25, 27 (private collection, New York),
32, 34 (National Palace Museum, Taipei), 81 (private collection, Sydney), 83, 87
Britstock: p. 19 (Antonio Diaz Meira), 38 (Darrell Jones), 38 (S. Sahuquet)
Bruce Coleman: P. 20 (John Shaw), 35 (Pacific Stock), 39 (Pacific Stock), 41 (Pacific Stock)

A Practical Guide to

Body Art

Hilary Hammond

CAXTON EDITIONS

Contents

Contents

The enchanting art of body painting

There is something quite enchanting about body art. Intricate and delicate motifs, interlocking geometric forms and tiny flowers characterise the art in its most traditional form. Practised for centuries in the Middle East, India and Africa, body art was linked with the traditions of marriage, birth and death. It is quite possibly one of the oldest art forms known to man.

Ancient cultures made a ritual out of henna painting, one of body art's most traditional forms. For the women who practised it, it was a beautiful and enriching experience. An ordinary pair of working woman's hands could be transformed into a work of art; dusty, path-worn feet could be made to feel exotic and sensual. Women painted other women, often in groups, and became closer to one another as a result of the experience. Body painting was a way of bonding, becoming part of the sisterhood.

Over the years body painting has continued among the cultures of the east and the third world. By the 1960s and seventies, however, it had reached the West. This was the time of Flower Power and the Peace Generation. The younger generation were taking over the world and they were looking east for inspiration. One of the ideas they found was body painting – it was breathtakingly beautiful and astonishingly easy to do. Western women were soon creating their own hybrid designs, drawing for inspiration on the many photographs of Indian and African women that were published at the time. Indian culture, in particular, was everywhere. Students covered their walls with posters of decorated women.

Right: a woman applying henna.

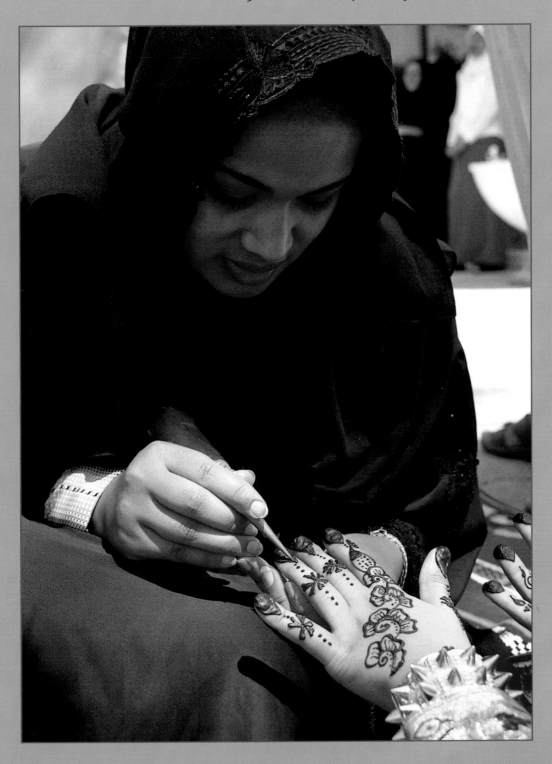

The enchanting art of body painting

Twenty years further on and body art has again caught on as the thing to do. This time, however, the trend has been spurred on by the stars of music and television, as media celebrities have brought it much more popular appeal. Now you don't have to be a hippy to be seen with hennaed fingers, you can be just about anyone!

The number of high profile celebrities that have been seen sporting body art recently has brought the art form more popular appeal than ever before. US singer songwriter Prince has had himself decorated, as has the actress Demi Moore and American superstar singer Madonna, who was hennaed for her recent pop video 'Frozen'. Mel C has an impressive array of designs on her body these days.

Cosmetics manufacturers have seized the opportunity, and have started to produce their own designer versions of the technique, using rubber stamps and pots of dye paste. Popular motifs reflect the mood for the New Age, with characters from Zen buddhism and Japan.

Henna tattoos, temporary transfer tattoos and body paint are most popular among young women, probably because of their non-permanence – henna paint only lasts four to five weeks and body paint, ink and dye only lasts a few days. All these substances are totally harmless and have no side effects, and this is probably the reason they have become so popular. Also, unlike permanent tattoos, you do not have to go to an artist to have them done.

The enchanting art of body painting

Henna paint, cosmetic dyes and paints are now readily available; your local ethnic shop is almost certain to stock them, and will probably know of a body artist who works locally too. It's also well worth checking out the Internet for suppliers. In America there are now body art salons where you can go to have yourself painted by top-name artists. Salons have now started up in London and it will only be a matter of time before they spread elsewhere. Body painting is big business!

While body art is not quite so big in Europe, it is quickly catching on, helped by the current interest in it among club-goers. It's chic and it's hip. It doesn't cost too much and you can easily do it yourself. What's more, you can customize body art to suit yourself. As any body artist will tell you, no two motifs ever turn out the same. So be unique, be adventurous. You can create a pattern of your very own, find a motif no one else has used before.

This book is intended to help get you started. Body artists often draw on the styles of the great civilizations of around the world as a basis for their designs, so take a look through our own potted style history to give yourself some ideas.

Once you've looked through the book, get yourself some paint and take a chance – it couldn't be easier!

A body art history

The origins and traditions of body art

Henna body painting, or henna tattooing, as it is sometimes referred to, has been practised for thousands of years throughout India, Africa and the Middle East. Traditionally believed to bring good fortune, happiness and to engender a sense of well-being, the art form was most frequently practised in association with special occasions and ceremonies such as marriage or childbirth.

Archaeological evidence suggests that the Pharoahs used henna to colour their nails, hair and hands – the dye was used to stain the toes and fingers of mummies prior to mummification. The Egyptians chose strongly geometric shapes as their preferred henna style.

Right: The crowned head of Nefertiti.

Below: part of a banquet scene from the tomb of Nebaum; the subjects' faces and limbs are highly decorated.

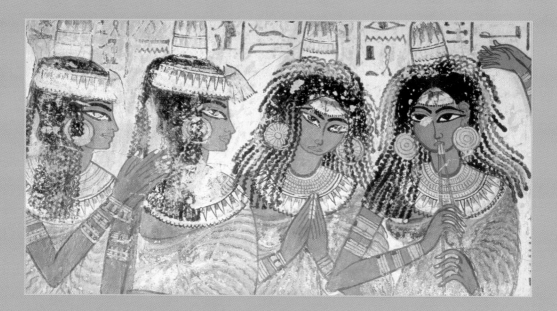

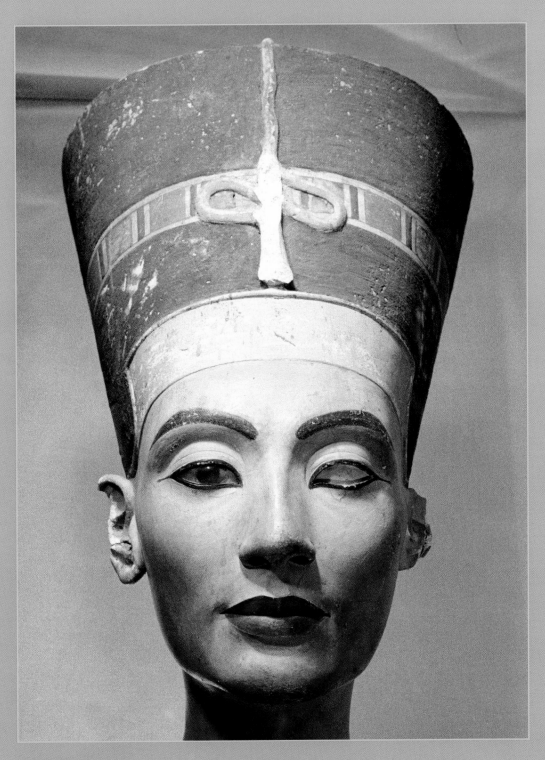

A body art history

It is thought that henna was brought to India by the Monguls in the 12th century AD; it was brought from the Middle East and North Africa. On the Indian subcontinent ancient cave paintings have been found that depict the Hindu deities decorated with henna paint.

As usage spread, so the rituals and beliefs associated with this ancient art form grew. In India, princes and kings tattooed themselves. Henna grew to be embraced by the Hindu culture.

The prophet Mohammed embraced henna, as did his wives. Subsequently, the body decoration has found a permanent place within Islam, with popular designs mirroring those used in textiles, carpets and carvings.

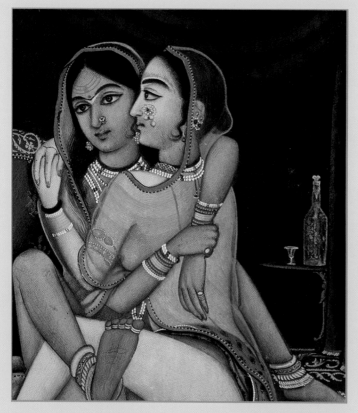

Left: a page from an erotic album painting – origin, India. The women both have symbols painted on their foreheads and henna on their fingertips and feet.

Styles from around the world

Body artists almost always plunder history for inspiration. Many of the most popular designs used by today's body artists are based almost exclusively on designs used by the ancient cultures. There are the traditional designs used by henna artists around the world, and now new hybrid designs made up from the imagery created by other cultures, such as Zen logos, South Pacific emblems and Oriental motifs. Mix this with today's New Age imagery and you've got the look.

The style history of the great cultures of the world would take an entire book to write. Here instead are just a few styles from around the globe to get you thinking about your own designs.

India and Asia

It is in the hotter parts of India and Asia that henna, or mehndi, is most used. This is quite possibly due to its cooling, therapeutic qualities. Here, body painting forms an integral part of the traditional wedding ceremony – tradition has it that the deeper the henna dye, the longer the love of the couple will last.

Traditional styles of decoration are very much kept within the family, with mothers teaching daughters their own exclusive designs. Styles may be kept in a family for generations.

In India, henna styles tend to be detailed and floral, often covering hands and feet completely. Religious beliefs govern what can and cannot be drawn – for example, a religious symbol will never be painted on the feet.

Overleaf: Geometric and floral decorative henna patterns are applied to adorn the hands and feet of young women on occasions such as weddings.

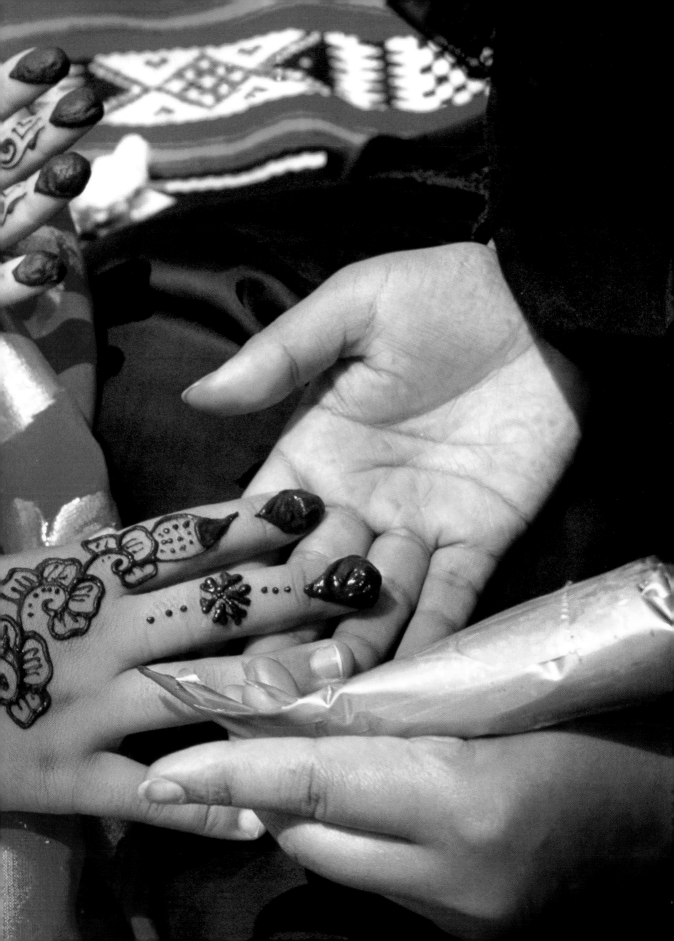

Indian style

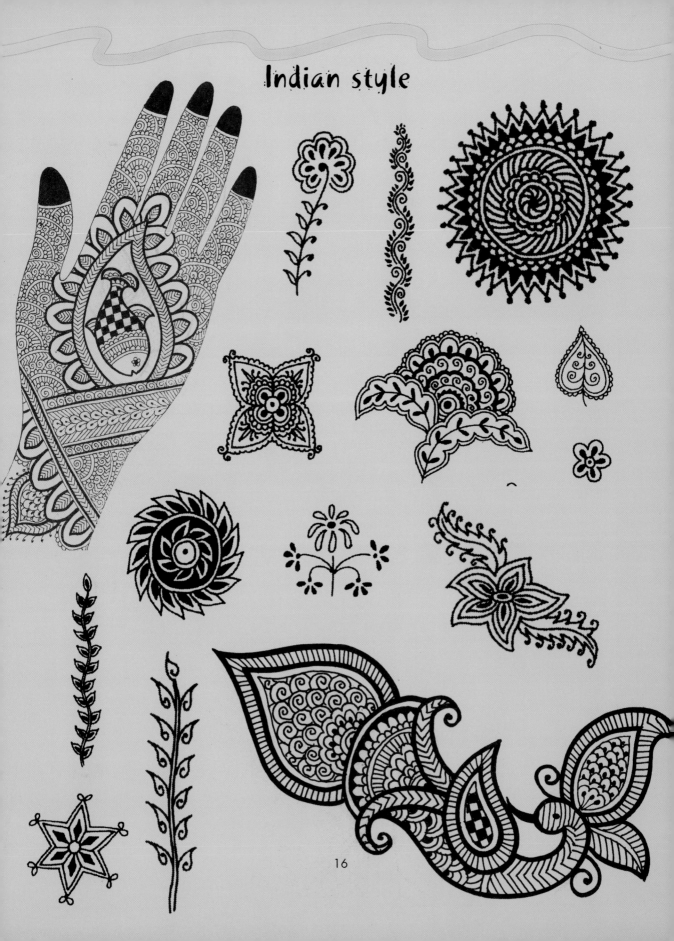

Asian style

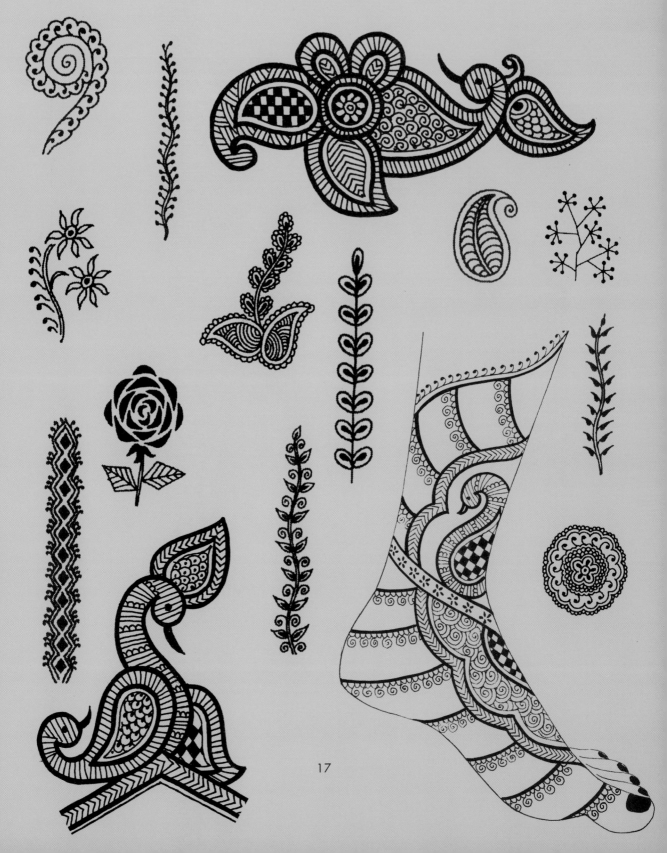

17

Styles from around the world

The Middle East

Arabs will tell you that 'If I don't speak the truth, I won't present my hand for henna'. Here, henna is believed to be a good omen that wards off evil and bad luck. Practised in Turkey, Iraq, Iran, and Saudi Arabia, henna painting tends to be exclusively floral and less densely applied. Almost every pattern will be finished by painting the finger or toe nails. You are most likely to see henna body painting at a wedding ceremony, as it is brides who are most frequently painted.

Africa

In Morocco, pregnant women have symbols and ankle bracelets painted on their ankles in order to protect them throughout childbirth.

Among the nomadic tribes of North Africa, tattooing is commonplace. Here again, designs are handed down from mother to daughter. Motifs are believed to ward off evil spirits and to protect the wearer against bad luck and trouble.

African designs are totally unique. Motifs tend to be bold, angular and often cover large areas. Geometry features a lot, as does in-filling of shapes.

Religious imagery sometimes finds its way into body painting, and certain tribes have modified zoomorphic/animal shapes. Much time is spent on decorating outwards from a central motif

Right: A moroccan girl displays the geometric patterns which adorn her hands.

Overleaf: Samburu Warriors in Northern Kenya.

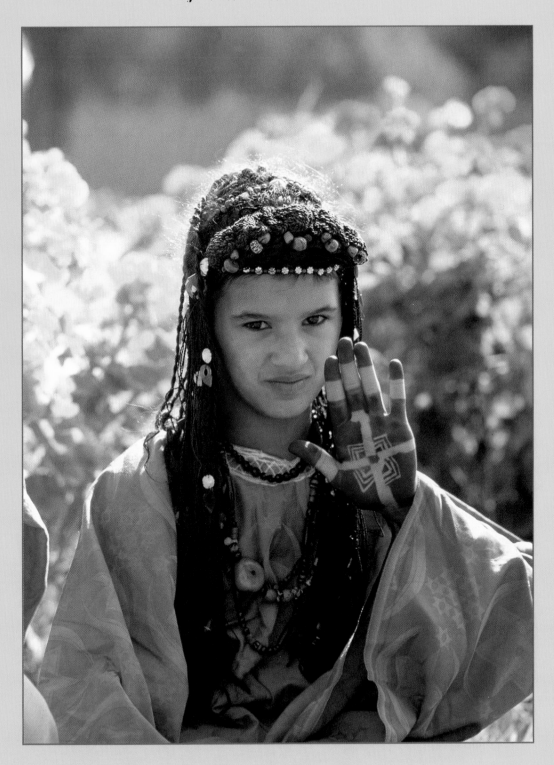

19

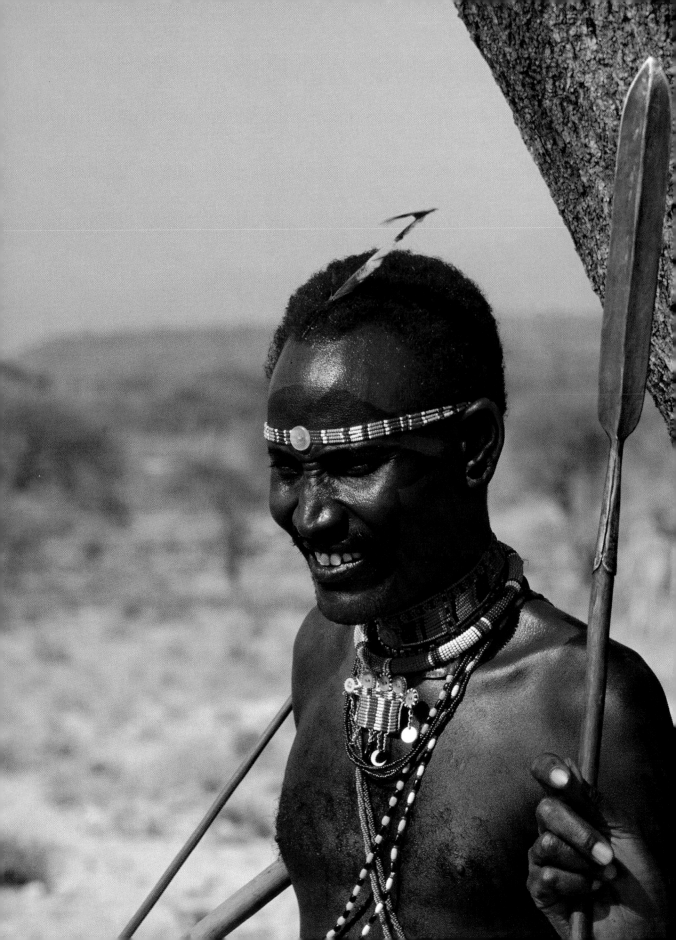

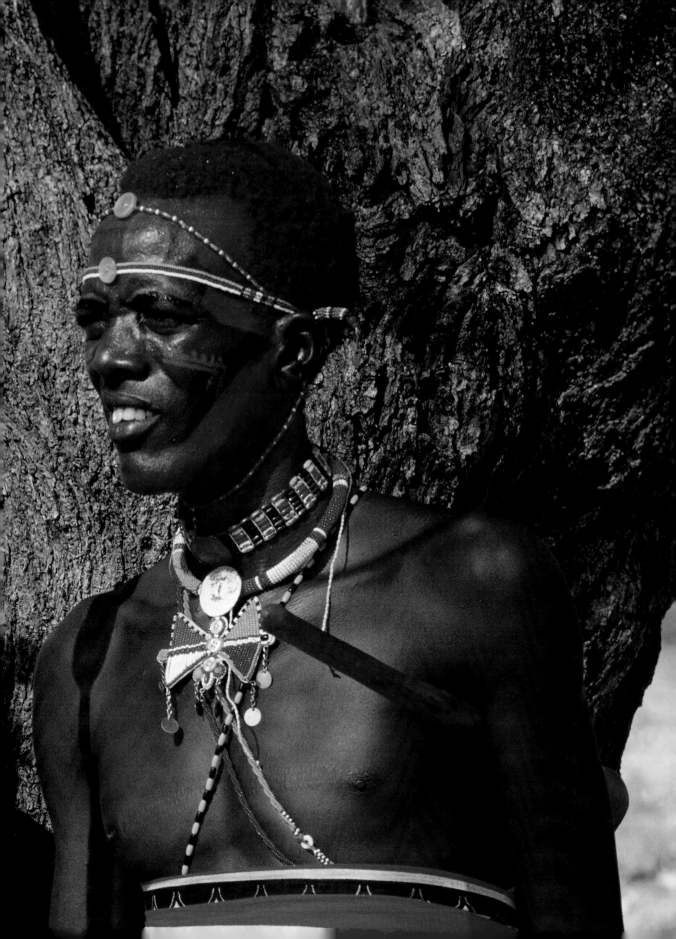

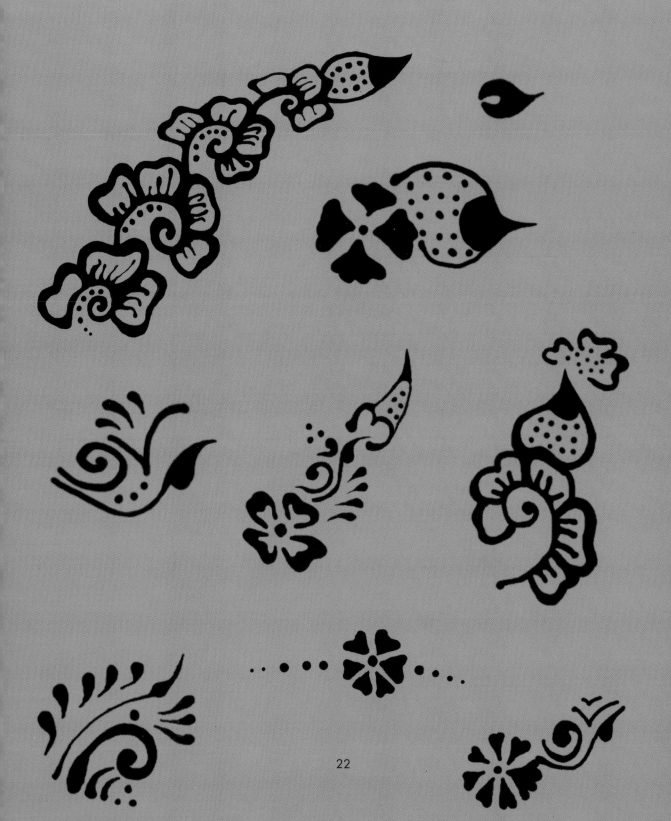

22

African Style

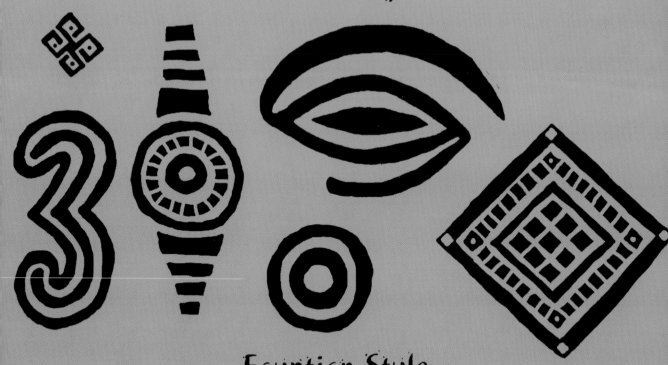

Egyptian Style

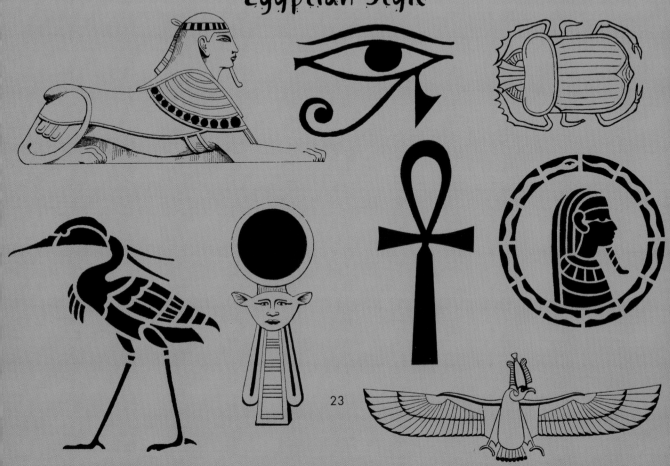

23

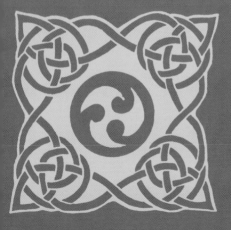

Celtic art

Knotwork, spirals, key patterns, chevrons, pagan symbols and mythical animals typify the art of the Celts. Celtic art is a truly indigenous British art form. Largely symbolic and often linear in design, it lends itself to today's passion for abstract, minimal forms. It short, Celtic art is a designer's dream.

The art of the Celts at first sight looks to be extremely complicated. Twisting rope-like forms crossing and recrossing in perfect symmetry may not be what the novice has in mind. Fear not, however. These complex mathematical forms are easily simplified. You can create your own Celtic knot quite easily.

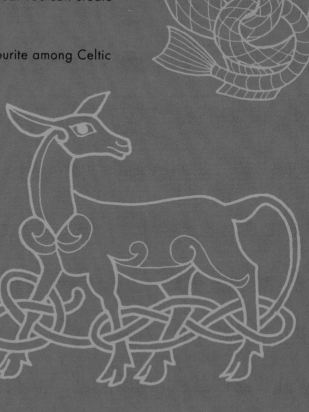

Animal motifs were a popular favourite among Celtic artists. Dragons, wolves and horses , sometimes realistically drawn, sometimes stylized, make subtle and evocative motifs. Birds and fish – which Celtic designers enjoyed incorporating into various motifs – can also be rendered in henna without too much difficulty.

Styles from around the world

But if it is a look closer to the traditional that you are after, take a look at Celtic spiral forms. For the Celts the spiral was a truly symbolic form. It meant magic, the beginning of time, the universe, everything. The spiral can be found on enamelled bronze ornaments, and was later much used to decorate stone monuments. Spiral motifs came in one, two and three coils. Other forms comprised several spiral forms, linked together.

Below: a celtic bronze ornament decorated with spiral designs.

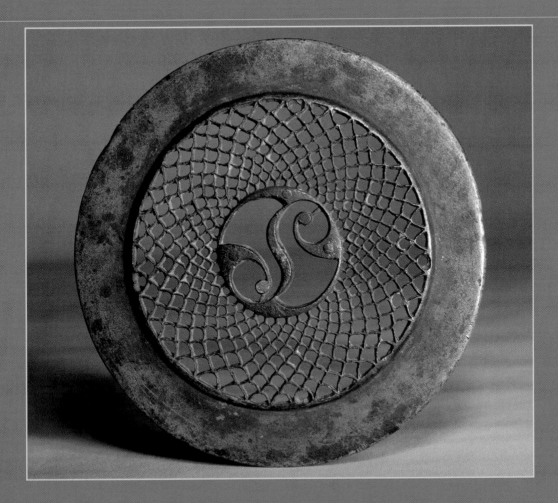

Do-it-yourself Celtic

Celtic art has become something of a profession today, but it need not be as technical and mathematical as the experts claim. Here are a few basics to help get you started:

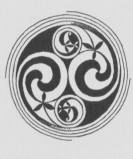

Spiral One of mankind's most basic design motifs. The Celts used it a lot, to make simple designs and complicated animal forms.

Key pattern A series of diagonal lines, interlocking in Chinese-puzzle type style. Motifs often repeated.

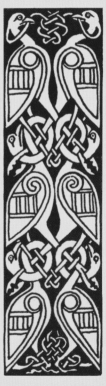

Interlacing is often extremely intricate often weaving lines in and out and incorporating abstract forms and knotwork.

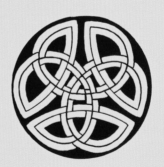

Knotwork As the word suggests, this motif looks a lot like a knot, with one strand or line looping over and under itself.

Zoomorphic A motif that is part animal part abstract design. Animals often appear in pairs, ranging from wolves to geese and lambs and are strange and wonderful.

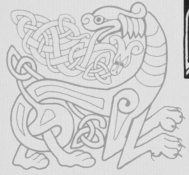

Native American Indian

The indians of North America knew all about what it meant to live close to the land, the sky and the sea. Their art depicts birds, plants and animals. They made totem poles, ritual figures and totemic motifs in order to get close to the elements – the sun, the wind, the earth.

The tribes of the northwest coast developed highly complex societies. Here Indians carved heraldic and ceremonial objects, painted and weaved. As it was readily available, wood was much used.

Below: a cloth painting depicting a plains Indian with decoration on his face and limbs.

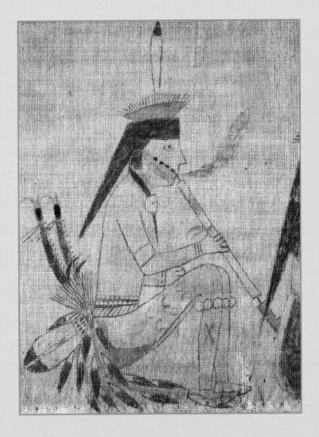

Certain motifs were common. Zigzag lines, dotted lines and chevrons are popular framing devices. Inside you might find stylized flowers or people.

Silhouette drawings and X-ray representation are typical of the northwest coast graphic style. Often a silhouette eagle appears linked with its mirror image, two eyes becoming four eyes. Sometimes what at first appears to be a head on closer look reveals a fish, eagle beak or pair of wings.

Many of these stylized forms became 'legends' or motifs, to be used again and again, as part of the indian's artistic vocabulary, handed down from father to son, from Shaman to Shaman.

American indians liked to paint themselves with various natural pigments. Warriors going into battle and warriors who had come home painted themselves from head to toe. Women painted their faces and sometimes their hands, often for pre-marriage ceremonies. Their designs were almost always linear – score marks and finger prints, drawn across cheekbones, around eyes, under the mouth.

Styles from around the world

Unlike Celtic art, the motifs and legends of the American indians do not adhere to set mathematical rules. You can draw these designs freehand without too much difficulty.

Note the use of shading and in-fill. Motifs are drawn out, then small parts filled in with block colour. Some lines are thickened to add emphasis. Keep the motif simple, unfussy. Use bold lines.

Many motifs are mirror images. Simply divide the image straight down the middle to reveal its construction.

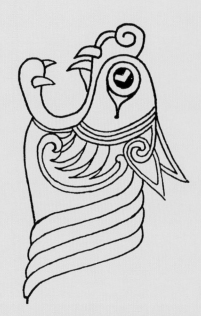

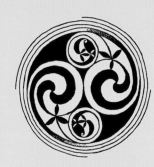

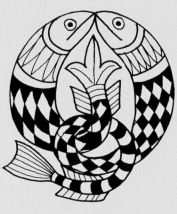

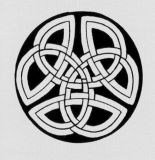

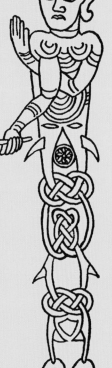

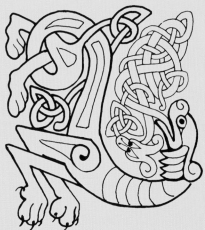

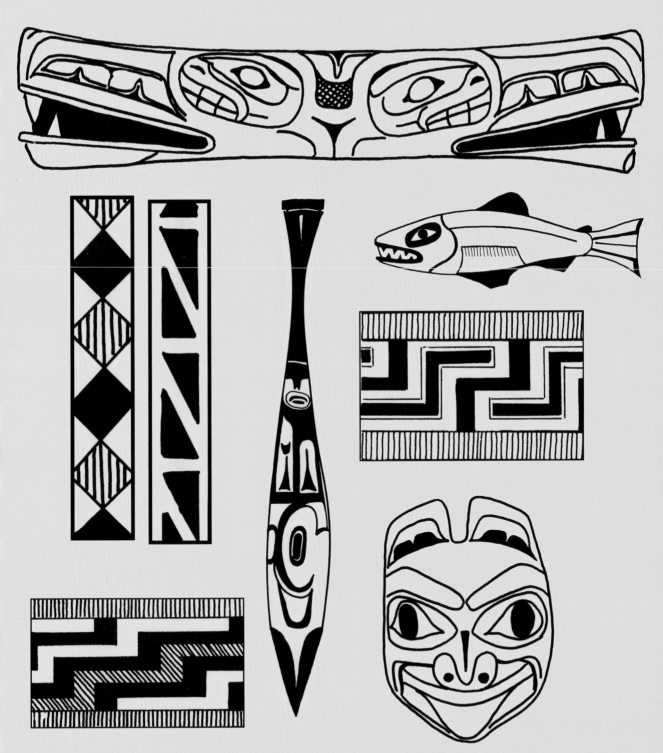

Ancient Mexico

The New World's most advanced civilization, the Maya dynasty
of ancient Mexico produced palaces and temple pyramids, an
intricate calendar, complex hieroglyphics and highly
sophisticated art forms to rival that of any classical civilization.

It seems the Mexicans had a passion for motifs. The Maya
had already bequeathed to the region a complex form of calendar, comprising
beautifully crafted numeral-characters that were the equal of any Egyptian hieroglyph.

And the centuries kept the tradition alive, developing these forms into motifs or
'stamps'. These were originally used for trade, but
became widely used for purely decorative purposes.
Made of baked clay, these tiny objects, sometimes
measuring only one centimetre square, are still used
today to print small-scale patterns and designs on to skin, cloth or paper.

Geometric design is common among stamps, especially the
older ones. As craftspeople became more skilled naturalistic
designs – plants, flowers, human figures and animals – were
made. These subtle, often unassuming cameos employ the
minimum of detail to produce the form – a line here, a dot
there. Somewhat Zen-like, many of these forms have symbolic or ritual meanings.

Mexican motifs lend themselves to body painting. Indeed, the ancient Mexicans
were known to decorate their arms upper bodies and hands with prints. Tattooing of
both men and women after marriage was the thing to do.

The motifs

Zigzag lines, double bands, triangles and circles, parallel lines, step patterns and concentric squares are favourite motifs. Lines tend to be of the same chunky thickness. Mexican art also uses spiral forms, sometimes angular, sometimes curved, almost always in combination with squares, dots and parallel lines.

Ancient Mexicans believed the world was flat; they also believed it was the back of a giant crocodile. The sky was a serpent. Other animals frequently found on stamps are dogs, monkeys and jaguars.

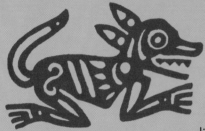

Flowers occur a lot in Mexican art, although most floral forms are difficult to identify as being a specific flower. Some forms look a lot like sunflowers, others are tulip-like, daisy-like and rose-like. Most have had the geometric make-over.

Ancient Mexican artists had a great sense of humour – take a look at their monkey pictures! They had fun with the human form too. Their people can be scary, silly, squat, serious and sensuous.

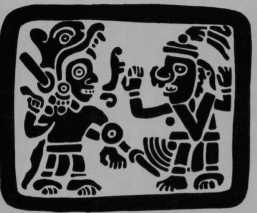

The Maya wrote down their beliefs in books. Sadly only a handful still survive, but what they are full of are extraordinary glyphs (a type of 3-D hieroglyphics) recording history, songs, 'science' and ritual astrology. These tiny symbols are subtle and beautiful.

Styles from around the world

Art from the Orient

The art of China and Japan could fill a book in its own right. Both cultures produced artisans whose renown is known throughout the world – exemplary potters, glass-makers, calligraphers, print makers and water-colourists.

It was the start of the Han dynasty in around 206BC that saw the rise of painting and calligraphy. Calligraphy was and still is regarded as one of the greatest art forms, expressing not only words but the strength and character of the writer.

And it is Chinese writing that features strongly in today's body art. If you have a strong, steady hand, a keen eye for copying detail, and a certain flair with the paint brush, then freehand body art calligraphy is well worth a try.

Chinese watercolour work lends itself to body painting, especially using cosmetic inks, which work in very much the same way as watercolour. Oriental painting is elegant, stylised and extremely graphic in its approach. Take a look at 14th century porcelain or the exquisitely beautiful scroll paintings of the 15th, 16th and 17th centuries for inspiration.

Favourite subjects – trees and mountains, birds, grasses blowing in the wind, flowers and dancing fish.

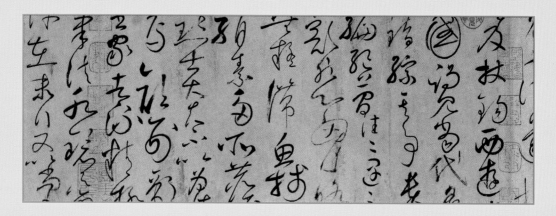

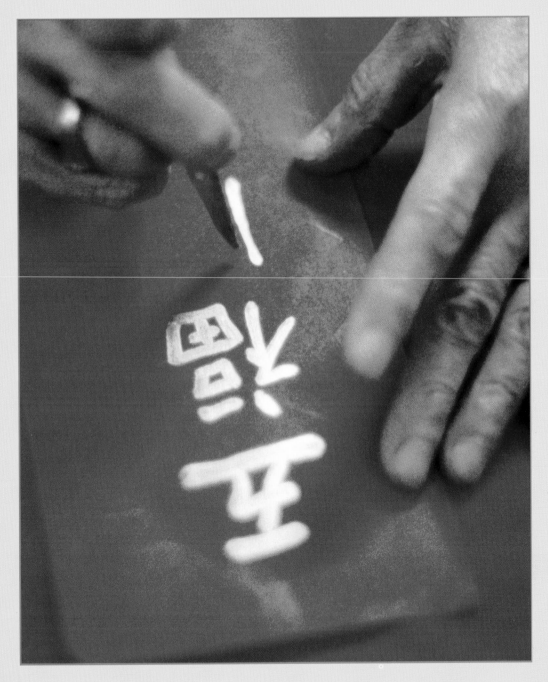

Above: Chinese letters on red cloth.

Left: Chinese calligraphy dating back to the Tang dynasty – AD 777.

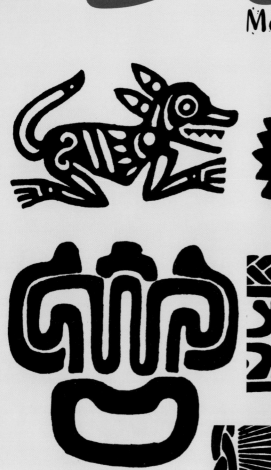

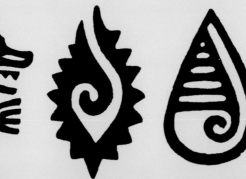

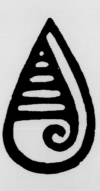

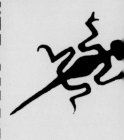

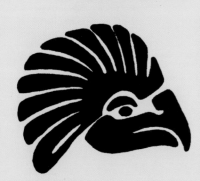

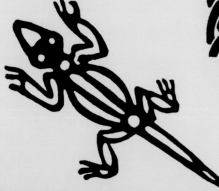

The South Pacific

Where there's sun, there's body art. There's no doubt about it, where the weather is warmer, the human body more exposed, then you'll find body art. In the South Pacific this is certainly the case. Here traditional tattoos cover a lot of the body, from head to toe, and are done on both men and women. The tattoo is highly regarded as an art form in its own right.

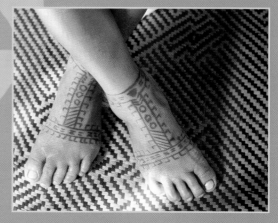

Pacific island art tends to be heavy, linear and often incorporates a bit of fun. Artists like their animals, funny human faces and grinning 'cartoon' characters. Mix these together with some repeating zig-zag patterning and you'll get close to the effect.

Among frequently used motifs are the rising sun, shells, stars, leaves and flowers.

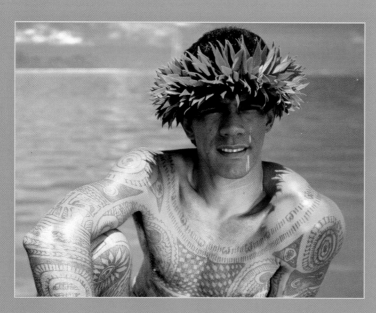

Above: tattooed Tatitian feet.
Left: a Polynesian man covered with body tattoos.
Right: a New Zealand Maori with facial markings.

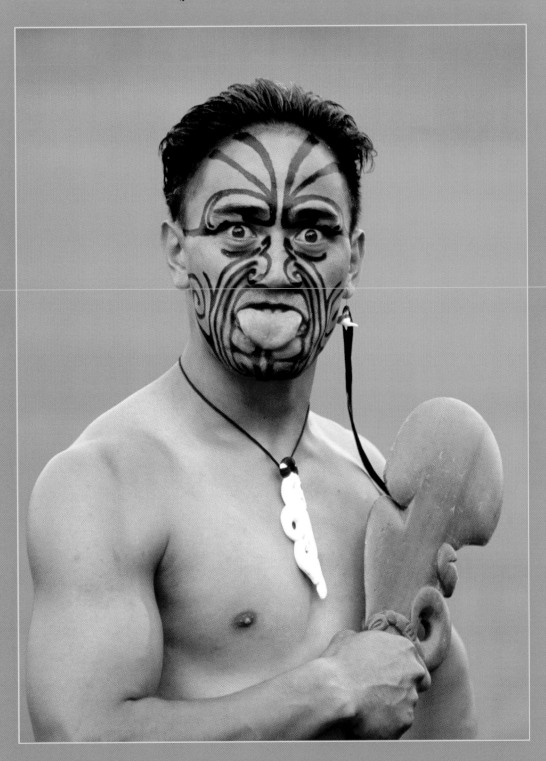

New Age art

New Age has certainly come of age in style terms. Now it's not just a lifestyle and/or a belief, it is just as much about a look, a fashion statement and a whole design culture. So what's the New Age look?

New Age is basically all about one world, one race, one belief system, all at one with the wider universe. Stylistically this interprets into a variety of motifs taken from cultures from across the globe.

Key motifs are the Yin-Yan symbol, celestial suns and moons, Hindu and Buddhist mandalas, Zodiac symbols, the International Peace Symbol, mystic mazes and the anti-nuclear symbol.

Other favourites include hearts, trees, roaring lions (taken from Rastafarianism) and smiling suns.

New Agers love all colours. There isn't a lot of black and white here – feel free, use everything in whichever way you want! The rainbow is beautiful, and you are beautiful too!

Right: a striking portrait of a man from Papau New Guinea in tribal dress

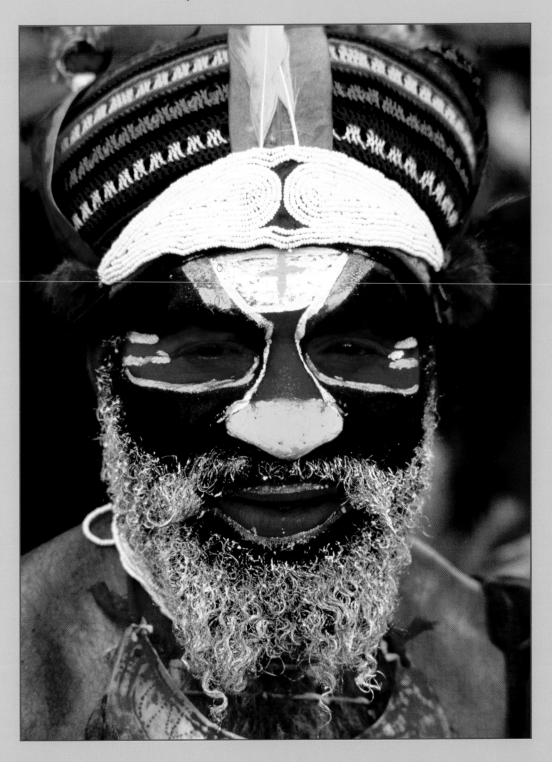

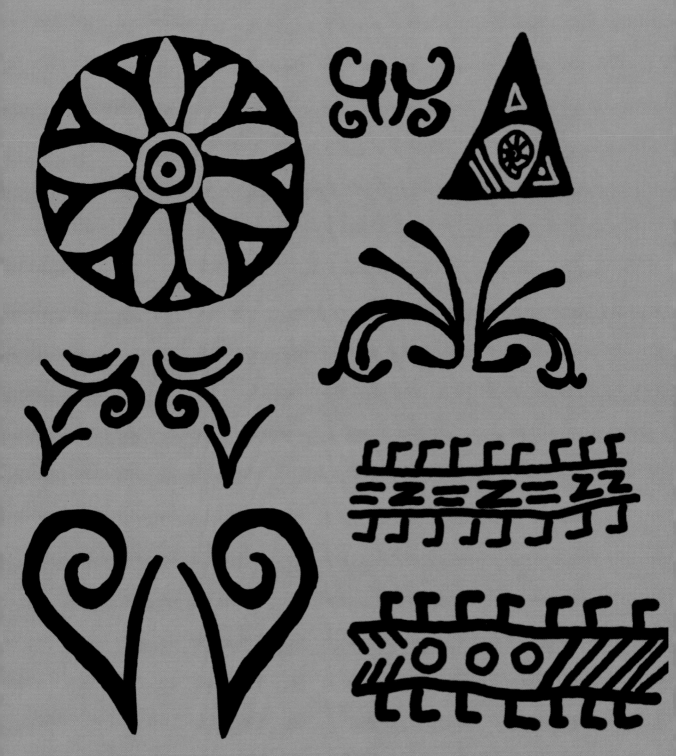

42

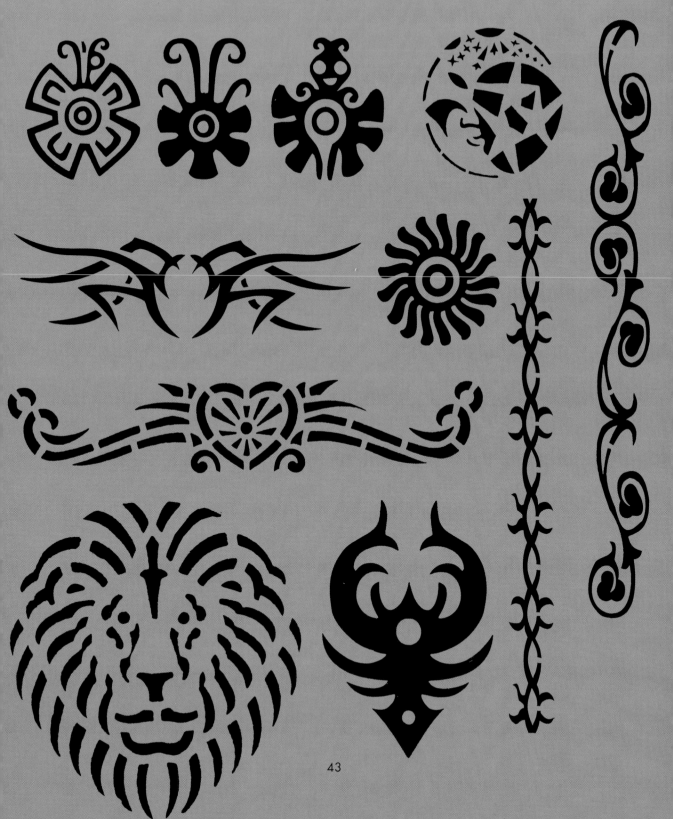

43

Body art today

Body art has come a long way. Today it's not about ancient and long-lost civilizations, about traditional ritual and magic, it's spread West and become truly multicultural.

Today's body artists are professionals. They follow fashion, know what's 'in' and can create just about any design. Designs, while still largely drawn from traditional motifs, now say much more about the person drawing them and less about the traditional culture from which they originated. Like fashion, top henna painters are a name to be seen 'wearing'; Madonna might be seen in Gautier, with henna by Loretta Roome.

Body painting took off in the United States around the mid 1990s, when a gallery in East Village, New York put on show photographs of Mehndi body art. The gallery also held live demonstrations. This was enough; the press were full of Mehndi articles, the television screens with body art feature programmes. People flocked to see what was new, the fashion had caught on.

While traditional Arabic and Indian designs are still very popular today, now the art form has broadened out into a range of other styles. Check out 'tattoo' or New Age style. This draws a lot from contemporary tattooing, using bolder, larger forms. Motifs may be figurative, with stretched, tapered lines. Symbols include the sun, butterflies and lizards.

A lot of body art is customised; it does not reproduce traditional forms, but takes ideas from pretty much anywhere. Here the henna painter becomes an artist, making a statement perhaps. Symbols might be Om, Yin and Yang, the Eye of Horus, the international sign of peace.

The best thing about body art today is that it's an open palette! There are no rules, you can customise, adjust, use motifs from anywhere. Use paint, ink and transfers to make a statement about you.

44

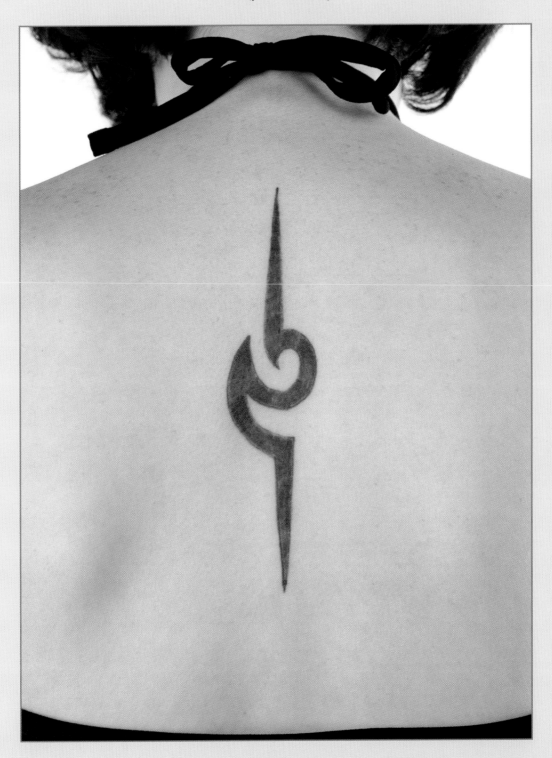

Body art today

Accessories

Don't forget about accessories – and here I don't mean the handbag or the shoes! Today's body art is not complete without the addition of the bindi, body jewels and of course not forgetting body glitter and thumb rings.

Traditional bindis are tiny felt, velvet or bead pieces that you stick on to the body. They come in all sorts of shapes and sizes and colours and are easy to use. You can also buy fancy jewel bindis, belly button bindis and star and heart bindis.

Body glitter speaks for itself. It comes in scented and non-scented versions and pretty much any colour. All body glitter is non-permanent. Don't get too carried away though – while body glitter is fun its best used in small amounts to avoid looking totally silly!

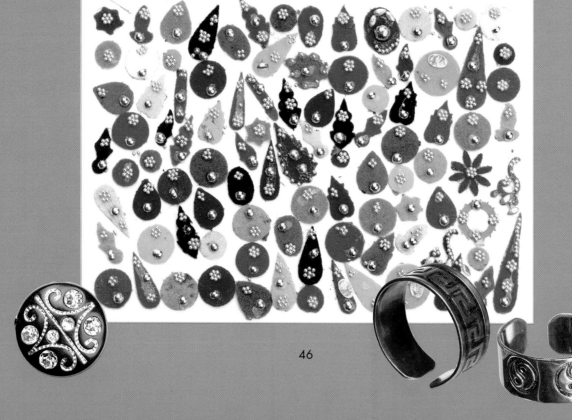

Henna body painting

A beginner's guide

Henna painting can be a lot of fun. Whether you're painting yourself or someone else, you will get a lot of satisfaction from actually being involved in the process itself, and in watching your design as it evolves and alters in the weeks to come.

Henna is a completely natural product that has been used for thousands of years. However, if you have particularly sensitive skin and are concerned about an allergic reaction, do a skin test before you start. To do this, apply a small amount of henna paste to a part of the body, scrape it off and wait for 24 hours. If there is no allergic reaction you should be safe to carry on.

Caution should also be taken when using essential oils. Always remember to use them to their correct dilution. If unsure, find out what you need to know before proceeding – never take a chance.

Finally, make sure you know what you are doing before you begin – remember, henna stains as soon as it is applied! Getting ready to start painting is as important as the painting itself.

1 **Make sure your work surfaces are clean and if necessary protected – remember henna stains just about anything.**

2 **Protect your own clothing and if necessary tie your hair back.**

3 **Get all your materials ready. Get some water ready. Get your design ready.**

Henna body painting

Henna paste

Pre-mixed henna paste is probably the easiest sort of henna to use. It comes ready made, in a tube with a nozzle. All you have to do is use it. Henna paste can be bought from ethnic shops and in some Indian supermarkets. You can also order it direct from retailers worldwide via the Internet. Colours include natural, black, blue, green, orange, red and purple, turquoise and brown. It is important to follow the instructions which come with the premixed pastes as some do not require the use of Mehndi oil when applying your designs usually these are the coloured pastes.

Henna powder is what the professionals use. Its best bought from a recognised supplier rather than at your local store, as it is important that it is fresh. There are many different recipes for making henna paste. Remember, once mixed henna only lasts three days, so don't make up too much. If you have some left over, you can refrigerate it for a couple of days. The recipe below is one that is commonly used. It will make enough paste for 8 to 10 simple designs.

1/2 cup water

1 tea bag

1.5 teaspoons powdered henna

1.5 teaspoons eucalyptus or 'baby' oil

Henna body painting

This is what you do:

1 Boil the water

2 Add the tea bag. For the blackest pigment, leave a
tea bag standing in it overnight.

3 Put the sifted henna into a bowl. Add the oil, but do not mix.

4 Using a metal spoon, add two tablespoons of the tea to the henna
powder, stirring as you go.

5 If the mixture is stiff, add slightly more liquid. Mix well, pressing out
any lumps with the back of the spoon.

6 Seal the container with cling-film and cover. Then leave the paste to
stand for at least four hours, away from direct sunlight. What you have in
the end is a smooth, set paste.

Henna body painting

Applicators

Most professionals use a plastic cone to apply henna to the skin. This looks a lot like an icing bag. If you buy a henna paste kit, then you get one free. You can improvise, of course. Good alternatives are a child's medicine syringe: ask at your local chemist for this or an icing bag with a fine nozzle.

There are other applicators. Professionals use fine wooden sticks for detail work. Here again, you can improvise. Toothpicks are good, also nail-care sticks.

You can also buy applicator bottles which are sold with a variety of nozzle sizes. These are very easy to use and less messy than the bags; good for beginners.

Sundries

To prepare the skin, clean it and set your design afterwards you will need:

cleansers – soap and water or rosewater

oils – eucalyptus oil, baby oil, olive oil

lemon and sugar

While working on your design, make sure you have the following close to hand:

Cotton wool balls and swabs

Flat toothpick or rounded flat knife

Paper towels

toilet paper and Scotch tape

Henna body painting

Henna application

When applying any henna design if you follow the steps below you won't go too far wrong. Obviously you need to change your methods depending on what king of template and design you are working to, for instance if using a stencil as opposed to freehand design the application is less precise.

1 First cleanse the area of the skin you are going to work on with soap and water and a cotton wool swab. You may like to use rose water instead.

2 Once dry, if you are using an adhesive stencil carefully place it in the correct position and make sure it sticks well to your skin without lifting at the edges. Do this before applying any oil to your skin or the stencil will not stick successfully

3 If you if you are going to use natural henna for your design you need to gently swab the area with diluted eucalyptus oil or clove oil (also called Mehndi oil) to help prepare the skin for the henna dye. (Note: any essential oil needs to be diluted before use – follow instructions for correct dilution ratio.) If you are using a coloured henna, in the main, oil is not required.

4 You are now ready to draw your motif. Slowly flow the henna on to the skin, as if you were icing a cake. Don't apply too much at once. If you are using a stencil, cover the area with an even layer of henna, making sure that the clear areas of the stencil are all covered with henna.

Use cotton wool swabs and toothpicks to adjust lines or remove any mistakes.

Clean your applicators frequently, using paper towels. Use a needle or pin to clean the applicator nozzle if it gets blocked.

5 When you have finished applying wait for the design to dry. This takes around 10 to 15 minutes. The henna paint is dry when it looks flat rather than shiny and wet. Do not wait for it to start cracking, however.

6 You now need to moisturize the henna paint, to encourage it to seep into the skin. Do this by either applying a solution of sugar and lemon – half a lemon to one teaspoon of sugar is enough to fix one average-sized motif – or pre-mixed Mehndi oil. Gently dab the moisturizing solution onto the henna paint using cotton wool swabs. Don't use too much solution – you don't want to wash off the henna.

Keep moisturizing whenever you notice the henna paint beginning to dry out. After a while the paint will retain the solution, and will stay moist.

7 For the henna stain to really take effect, the paint needs to stay on the skin for a minimum of five hours. Ideally it should stay there for eight hours, and overnight, if possible. Basically, the longer you leave the paint on the skin, the darker the design will be.

If you can bear to leave the henna paint on overnight, the best way of keeping it on is to cover the whole area in paper tape to protect it – you may also use a sealing product such as New-Skin, a spray-on fixative that seals the design while the stain develops.

8 When the motif has fully developed, take a clean cotton wool swab and rub the design to remove the henna paste. Any stubborn paint can be removed using a blunt knife blade. If you have used a stencil peel it off very carefully and clean off any adhesive that has been left by the stencil using a little diluted Mehndi oil

Aftercare

The colour you see when you first remove the paste is not the full colour; this appears around 24 hours later and will be much stronger.

Try not to wash new henna motifs, at least for a day or so. This will improve their life-span.

Using a moisturizer on the motif will help extend its life. Do not apply more than twice a day, however.

Henna body painting

What, when, why? Some henna questions and answers

How long does henna paint last?

Henna paint can last up to a month, although most henna products tell you they last only up to three weeks. In fact, it all depends on what part of the body you are applying it to, what type of skin you have, and how much that area gets washed and scrubbed. It also depends on how long you leave the paste on before scraping it off.

What parts of the body are good to paint?

Palms and soles of the feet are the warmest parts of the body and have the thickest skin. This means that the henna will penetrate further, and so the painting lasts longer. Other areas that are good to decorate are wrists, finger tips, forearms and the waist. Face and chest areas do not work very well, as the skin here is quite thin and exfoliates quickly.

Does henna only come in one colour?

Henna can vary in colour from light orange to dark reddish brown, depending on the type of henna used. You may have heard of 'black henna', which is also used. This is not recommended as it can be dangerous to the skin. Other colours, likewise, are not true henna and are therefore best avoided.

How long does it take?

How long a painting takes depends on how complicated it is. It might take 15 minutes to draw a simple motif, several hours to complete a wrist bracelet.

Does it hurt?

Absolutely not! In fact, it is quite soothing.

Coloured inks, paints, dyes and tattoos

A beginner's guide

Body art is not just about henna paint – today there are other alternatives that are just as effective and are in many ways a lot easier to use.

Body art has taken some tips from the professionals. Stage make-up artists use a variety of body paints, all of which are readily available.

Body paint

Body paint comes in two forms – grease and water-based. Grease paint, the favourite of face painters and actors, is popular because it can be applied fast and dries fast almost immediately in fact. Grease body paints come in all colours.

Water-based body paint also comes in all colours. Although it uses water, it is more user friendly than grease in that more detailed work can be achieved with less mess afterwards. Water-based paint acts very much like artist's watercolour; it can create subtle washes and fine detailed work. Body paint motifs last about one day.

Tools and useful tips

You will need very little basic equipment. Water-based body paint and grease paint is widely available – see back of book for some useful addresses. You can buy body paint in a pack – often selling as 'face paint' – or in individual bottles, sometimes called Indian body paint.

Coloured inks, paints, dyes and tattoos

In addition you will need

Paint brushes in three thicknesses - e.g. artist's watercolour or acrylic brushes

cosmetic sponges for applying paint

cleansing lotion/baby oil for cleaning skin prior to starting work

cotton wool for cleaning and soap and warm water

talcum powder to set the design

Here are some useful tips to help ensure your artwork is a success:

1 Make sure you select the correct size brush for the mark you want to make, and do not overload it with paint, instead apply a little pigment to the tip of the brush, then apply the paint a small section at a time.

3 Rest you hand on the body as you paint – this way you keep your wrist steady and ensure a firm even stroke

4 Body paints dry very quickly, so work as fast as you can.

5 For an all-over background effect, apply wet paint in broad circular motions, or with a damp sponge.

6 To blend colours, work rapidly, using a different brush for each colour.

7 To fix the artwork in place, rub a little talcum powder over the design.

Coloured inks, paints, dyes and tattoos

Body dye

Body dye motifs last about two to four days, although if you use a waterproof spray you can extend their life. The dye can be hard to get hold of – check out the Internet for a supplier or ask a local henna stockist for advice. The advantage of this cosmetic dye is its colour range, which is excellent. Also excellent is the effect, which looks almost exactly like that of an authentic tattoo, with no residual product left on the skin.

Basic technique

1 Cleanse the skin with an approved cleansing lotion and apply activator liquid to the skin – this will come as part of the cosmetic dye kit pack.

2 Cosmetic dye can now be applied. The dye comes in cones, just the same as pre-mixed henna. You apply it in much the same way as henna, by applying a little pressure to the cone thus forcing out the gel-like dye.

3 The dye remains liquid for about 30 minutes, giving you plenty of time to mix colours and shape your design.

4 Use paint brushes for fine details and blending and use water to lighten shades and give you that watercolour effect.

5 Once you are happy with your design leave it to dry – around 30-40 minutes, then gentry rub off the dry gel film to reveal the motif beneath. To remove, use soap and water.

Coloured inks, paints, dyes and tattoos

Body inks

Body or cosmetic inks come in all sorts of forms. You can buy bottles, pens and felt-tips, all of which have been specially manufactured for use on the body. Professional body artists tend to go for bottled ink, which is applied with a brush.

Useful hints

Cosmetic ink is alcohol-based – you need alcohol swabs or oil-based cosmetic cleansers to remove them.

Don't forget to cleanse the skin area before starting your design.

You need a set of brushes for this art work – one fine, one medium, one large.

Make sure you clean your brushes as you work to remove any residual colour.

Work fast – this colour fixes fairly quickly.

You can work colours over one another for 'watercolour' effects.

Set your ink motif with a little talcum powder.

Designs last 2-5 days.

Temporary transfers

Temporary tattoo transfers, sometimes called removable tattoos, are very easy to buy. They come in all sorts of styles and designs from Gothic hammer and sickles to rosy red hearts and fluffy rabbits and are a cheap and cheerful way of getting an instant body art effect.

Basic technique

1 Make sure you cleanse the area of skin first before applying the tattoo.

2 Most temporary tattoos are activated by water.

3 Place the tattoo face down on the skin.

4 Apply slight pressure using a damp cloth. Wait just one minute, then gently slide off the paper.

5 Rinse tattoo then allow to dry naturally.

Transfer tattoos will last up to one week and are remarkably realistic. They will withstand washing and are only removed using alcohol cleanser or baby oil.

The body art portfolio

O kay, so now you've had the low-down on body art, some words about the the artistic cultures of the world and the styles they've left to us, and some useful start-up information on henna paint, cosmetic paints and body dye, let's get down to business!

Here are a number of projects you can try to help get you started. Each project uses a specific application and talks you through the technique and method. The finished result is pictured, and we've thrown in a few alternative ideas too. You can also create these designs using the other paints and techniques we have previously covered. Follow the steps outlined in the previous section to apply any of the material you choose, but remember always to also follow the manufacturers instructions on the paints and henna because some brands may differ slightly.

There are also pages containing motifs and traditional emblems which you can use for inspiration to create your own designs or interpret using the ideas outlined in this book. Whether you are planning a night out to a club or relaxing at the beach, let your imagination go wild. Make yourself stand out from the crowd.

Mexican Lizard

This intriguing motif is bound to attract attention. It can be created freehand using pre-mixed natural henna paste for a more delicate but long-lasting effect; or, as in the picture below, simply painted on with Indian body paints using the colours of your choice.

Premixed natural henna will last up to 4 weeks, depending on how long you leave it on your skin to absorb the design and how good your aftercare is. If you work in an environment which doesn't encourage body decoration it may be a good idea to go for the less permanent body paints for designs which are as exposed as this one is.

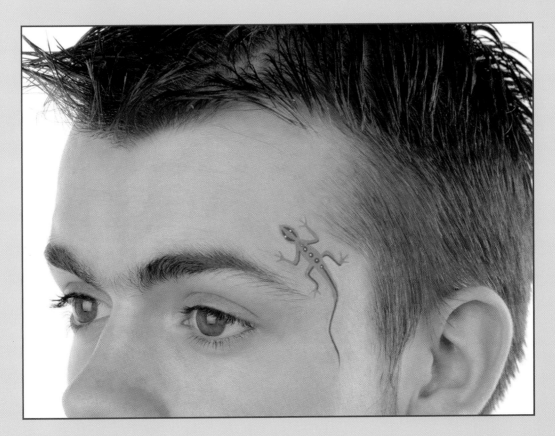

The body art portfolio

Because this is a freehand design you need to plan it carefully beforehand. It is a good idea, once you have chosen a motif, to practice drawing it on paper before you begin work on the skin.

Choose the colours you want to use and try these out on paper. Obviously if you are using water-based paints, mistakes are easy to rectify, but if you are using henna to create your design, practising beforehand is essential to avoid mistakes which could be more permanent.

A pale turquoise colour was used for the main colour.

detail was added using a light yellow to contrast with the turquoise.

Shading was added using a dark blue to give a 3-dimensional effect.

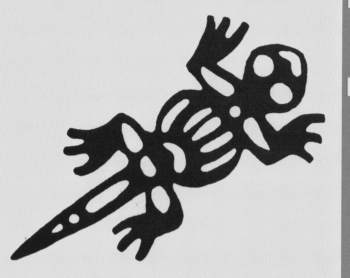

1 **First cleanse the area of skin you are going to decorate.**

2 **If you are using water-based body paints you can begin immediately to draw out your design.**

Use a small artists brush to apply the paints - this will allow you to create the fine detail

3 draw the main body legs and head first to get the proportions correct.

4 Fill the whole lot in with the main colour you are using - any fine detail can be painted over the top.

5 create the tail and follow the contours of the area you are working on - this way it will look much more natural

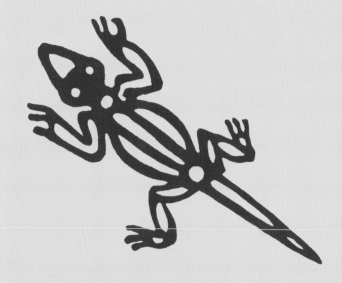

6 Once you have painted the main design make sure it looks right before you apply the fine detailing such as eyes and spots along the body and down the tail.

To give your lizard a 3-dimensional effect you can use a darker shade of paint to the main colour and create areas of shading under the legs and down the body.

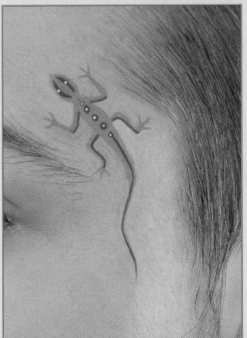

Arabian scroll

An Arabian work of art that's both discrete and eye-catching, created using temporary transfer tattoos.

Temporary transfer tattoos are remarkably realistic. They are also totally user-friendly – they apply easily, there's no waiting around for the motif to dry, and they last through washing and swimming. Designs can last up to one week, which means you can create a new look fairly quickly. Here we've given our look an extra twist, using Bindi body art jewels and body glitter – stunning!

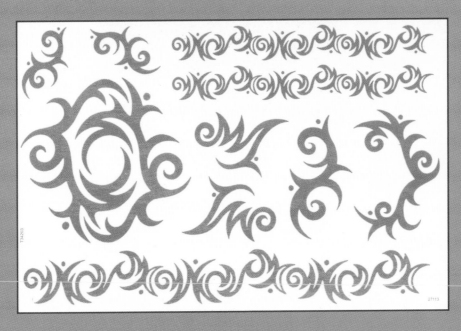

Above: temporary transfer tattoos usually come on sheets containing several design alternatives.

1 First cleanse the area of the skin you are going to work on with a cotton wool swab, soap and water. Pat dry with a clean towel.

2 You are now ready to apply your motif. Carefully select an image or motif that you feel would look good on the particular part of the body you are working on. If you are working on the face or neck, for example, you don't want to select a motif that is large and over-complicated. Keep your design simple. Also think about where the wearer might be going – what looks good at the club on the weekend might not go down too well in the office the next week.

3 When you have decided on the look you want to create, take the temporary transfer and place it face down on the skin.

4 **Wet the back of the tattoo using a slightly damp cloth. Wait for about one minute, then carefully slide the transfer off.**

If the adhesive backing wears off, re-glue with a non-toxic glue – office stationery glue sticks work just fine or eyelash adhesive if available.

5 **Gently rinse the tattoo with water, then dry.**

6 **To add to the effect, try placing a few Bindi body jewels around the motif. Body jewels can be both simple and elegant as well as glittery and fantastic. Most are self-adhesive, and so can be stuck on just about anywhere you want.**

For the complete effect, try body glitter too. This comes in roll-on tubes or pots – both contain temporary body glitter in a clear gel base. Simply apply and leave to dry. NB: most products are slightly scented.

Aftercare

Temporary transfers require minimal aftercare. You can apply a little body oil to keep them moist. To remove, use either adhesive tape or a little alcohol cleanser. Body glitter is removed simply, using soap and water.

New Age neck motif

This stylish New Age neck motif looks complicated but isn't. It has been created very easily, using a multi-tat stencil and a premixed henna paste. Coloured henna paste used to be frowned upon by Mehndi artists, who only used natural henna, but has now caught on in a big way. After all, why not use colour! Coloured pastes almost always come pre-mixed, which makes them quicker and easier to use and there are a wide range of colours to choose from. Here, however, we have used a natural coloured henna for a more delicate effect.

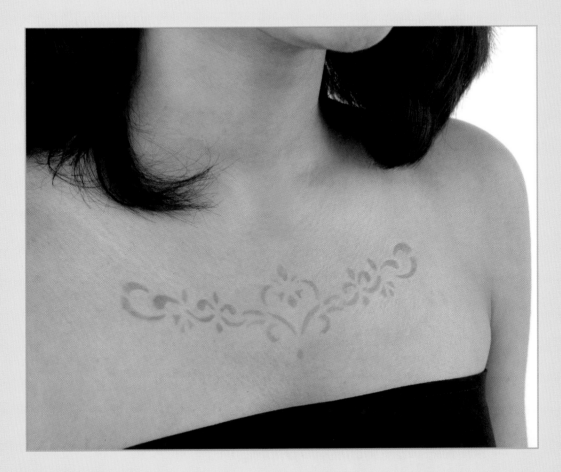

1 First cleanse the area of the skin and follow the steps for applying natural henna using a stencil.

Remember, if you are using coloured henna you do not need to treat the area with oil before applying your design.

For this design we have used a multi-tat stencil. These stencils are made of a contact paper-like material that sticks to the skin. They are normally recommended for coloured henna work, and while manufacturers recommend you use them only once, it is quite possible to reuse them.

2 Spread an even layer of paste over the openings of the multi-tat. Let the paste dry until it is firm but not cracking. If you are using natural henna you need to treat it and keep it moist by dabbing it with lemon and sugar solution.

You should leave the stencil and paste on for at least 5 hours, overnight if possible

3 If you are using a coloured henna paste you should only need to leave it on for 2 to 3 hours in order for the stain to prove.

4 When the time is up, remove the multi-tat and brush away the dry paste. Do not get the design wet for at least 24 hours after application, as this will diminish the colour.

follow the relevant aftercare for the type of henna you have used.

American Indian chest motif

A punchy graphic motif, created freehand using pre-mixed henna paste to create a long lasting outline design which can then be coloured in using water-based body paints or inks. This motif looks impressive and takes a little time to execute, but is well worth the effort. This design would also look great using a black henna paste to create the outline.

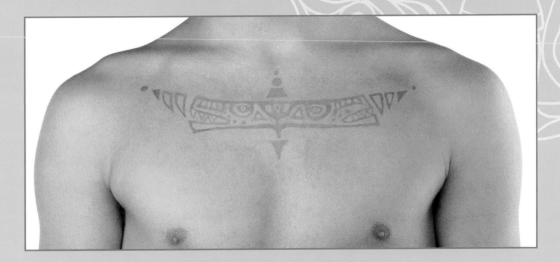

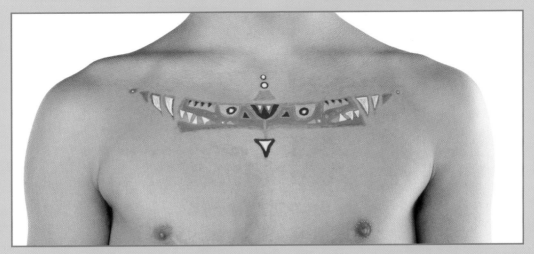

1 **Once again you need to follow all the relevant steps for applying either a natural henna or a coloured henna, whichever you choose to produce the outline of your design.**

Freehand painting is very exciting. It is also rather daunting for the beginner. The best way to get started is to practise the basic lines and shapes first, with pencil on to paper.

Because of this, you need to practise your marks first. Repeat them over and over again on paper, to get the feel of the curves, flicks, and lines. Once you start work on the skin, you need to be in complete control.

It's a good idea to avoid complex designs until you have mastered the more basic motifs. The design we have used is based on the above motif but has changed slightly to fit better with the area of the skin we are working with.

2 **When you are confident of your drawing ability you can begin the real thing. Draw the outline marks and nodal points first, then the defining lines, and lastly the detail and any filled in areas.**

3 **Rest your hand against the skin to help keep it steady. Move yourself around the motif as you work, do not ask your model to move.**

The body art portfolio

Use cotton wool swabs and toothpicks to adjust lines or remove any mistakes. Clean your applicators frequently, using paper towels. Use a needle or pin to clean the applicator nozzle if it gets blocked.

4 When the outline is complete you are ready to fill in the design using your preferred medium. Here we have used water-based body paints to create a strong solid blocks of colour

5 Work out first which colours you want to use and where, before you start applying them. Carefully paint in the areas you want solid using a small paintbrush.

The good thing about using water-based paints is that you can remove any mistakes quite easily. It also means that you can change the colours of your design whenever you like, for as long as the

henna outline is visible. Indian body paints (below) are very vivid when applied to the skin and come in a range of colours, often sold in pots of 11 or more.

6 The design should be dry within minutes. Try not to rub it too much and avoid getting it wet. It should last through the day and evening, but the colour will wash off very easily.

If you use coloured henna to decorate your outline this will last much longer. Follow the steps for applying coloured henna but be careful not to go over any lines as any mistakes will be more permanent.

Shoulder decorations

These intricate floral and striking modern motifs for the shoulder can be created using any type of body paint you prefer, depending on how permanent you want the design to be. Some have been painted freehand and others with multi-tat stencils. Whichever method you chose, the result is very effective.

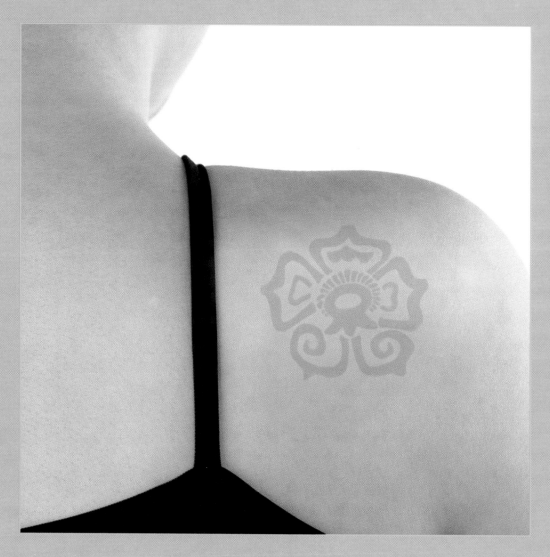

The body art portfolio

Make a bold statement with a large mexican floral design or be more discrete with a new age spiral or flower. All the motifs pictured have been created using natural and coloured henna.

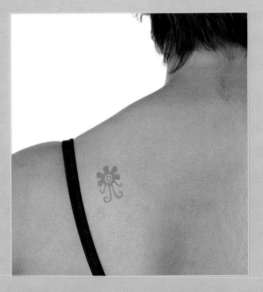

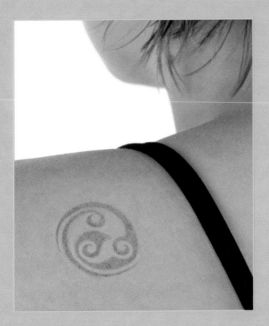

The design above was created using a purple henna paste with a mult-tat stencil. The design on the left was created using a natural henna with a multi tat stencil, and the design below using black henna paste.

The large mexican floral design opposite was drawn freehand using a natural henna, applied using an applicator bottle. The henna was left on for just 4 hours to give a very subtle effect. To make a bolder statement you could use a black henna to draw the flower and use brightly coloured henna to fill it in.

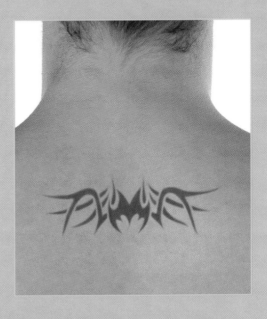

Celtic Spiral

An evocative Celtic spiral design, created by drawing the main design freehand using natural henna powder enriched with tea blend. Natural henna produces a colour ranging from burnt orange to dark brown. You can make it even darker using pure henna powder mixed with black tea water. Enhance the design as you like using water based body paints.

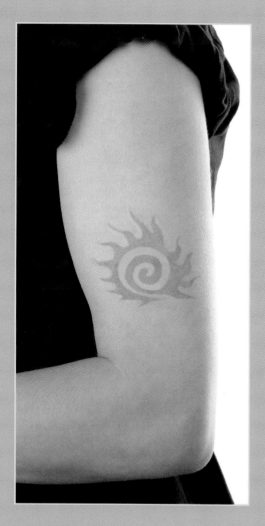
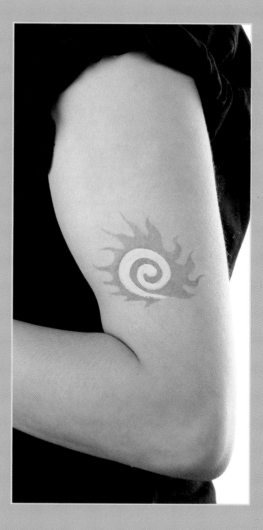

The body art portfolio

If you are not confident drawing freehand designs there are a wide range of celtic stencils available in various designs. If you want to be unique it is possible to make your own stencils for virtually any design you like.

1 **For this you need some thin waxed card. Stencil card is available from most craft shops and/or via mail order.**

2 **Draw or photocopy your design on to the card and cut out the areas where you want the henna paint to appear. It is a good idea to shade these areas first, to make sure you don't cut out the wrong bit by accident.**

Make sure you use a sharp craft knife when cutting out the stencil. It is a good idea to use a craft board or flat wooden chopping block.

3 **Tape down the stencil with masking tape to stop the stencil from moving as you cut it. Keep the blade square to the paper and cut positively. Finally, take your time. Cutting stencils out is a slow process.**

4 **The stencil can be glued directly on to the skin using a skin friendly glue available from most body art suppliers. This usually comes in stick form and will clean off easily when you remove the stencil.**

Mexican cockerel

This witty, curious creature makes a distinctive, eye-catching motif. It has been created freehand using pre-mixed natural henna paste. Make sure you use a fine nozzle on the applicator you have chosen as this design has a lot of fine detail. You could apply the henna using cocktail sticks or toothpicks in order to achieve the fine detail.

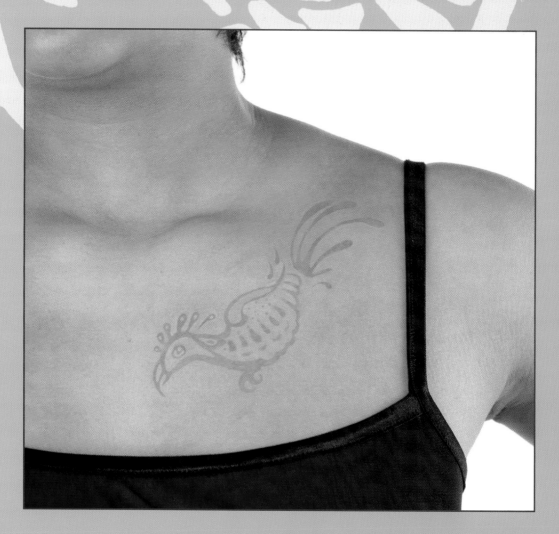

The body art portfolio

1 Before you begin to draw your design directly onto the skin it is a good idea to have several practice runs first. Take some paper and a pen and practice drawing the cockerel – tracing it first might help you get to grips with the flow of the marks.

2 When you come to apply the design rest your hand on the skin to steady it. Use cotton wool swabs and toothpicks to adjust lines or to remove any mistakes.

Clean your applicators frequently, using paper towels. Use a needle or pin to clean the applicator nozzle if it gets blocked.

There are many variations on this design and as you become confident you can experiment by adding your own personal touches.

This subject is also a good one to colour in. Body dyes are particularly effective and give a subtle translucent gloss to the design.

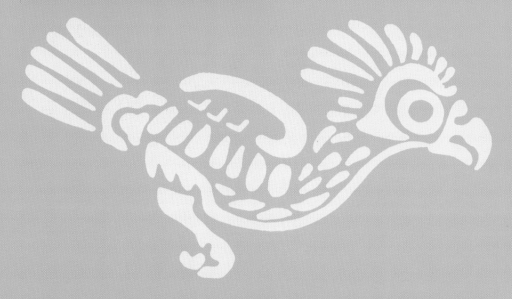

Striking arm motifs

Arm-band tattoos can be bold and striking. Permanent tattoos are often applied to the upper arm, an area of the body that is relatively smooth and easy to work on. Below we've recreated a striking American indian design) using a multi-tat stencil and black henna paste. You can enhance the design further by adding colour. Water-based body paints body dies {see right) or coloured henna are all very effective.

If you prefer something simpler, why not try to create an Aztec hand (see far right). This time we've painted the design freehand using natural henna and a steady hand!

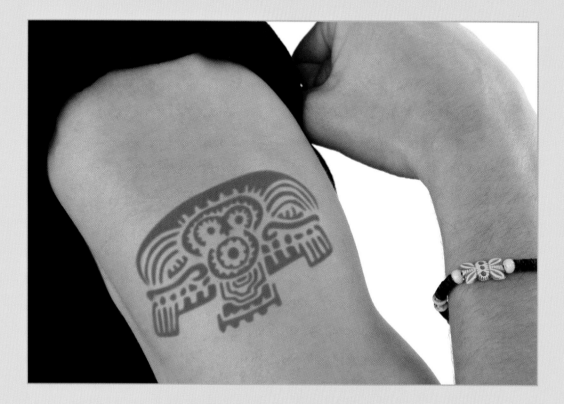

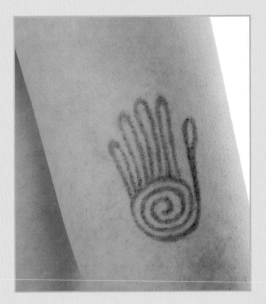

We chose to use a multi-tat stencil for the American Indian design (left) as it was particularly intricate and they work very well with coloured henna. However, when you are more confident many designs can be achieved freehand and there are endless references to designs and motifs which you can call on to create your own designs.

It is always a good idea to draw your design on to paper before applying it to the skin. This way you can modify the design to your personal needs and sort out the colours you want to use beforehand. This will save a lot of time and help to prevent any mistakes.

You'll find plenty of armband designs among the temporay transfers available in the shops. These are very effective and can last up to 7 days if you are careful in caring for them. They are easy to apply and give instant results (see below).

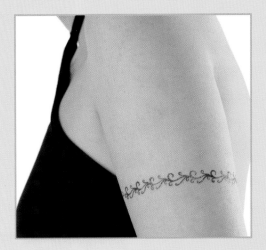

Oriental characters

Inspired by Chinese or Japanese calligraphy, stunning and subtle designs can be achieved very simply. There are many resource books for this kind of design and with the ever-growing influence of Feng Shui, I Ching and other Eastern practices on our lives, it is little wonder that the influence should spill over into body art. Multi-tat stencils of Chinese characters are available from body art suppliers, but you can also achieve them easily, simply by copying characters you have seen directly on to the skin. (You might like to find out what they mean first, however!)

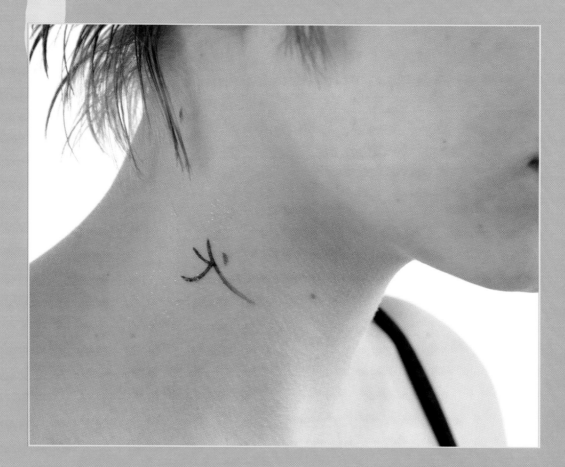

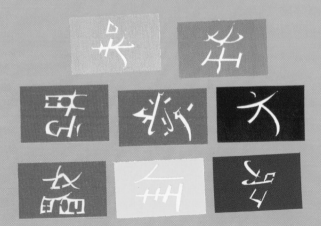

In the design on the left we have used a multi-tat stencil and black henna paste to create an attractive and subtle motif on the side of the neck.

If you are working freehand, the most important thing to consider when attempting Oriental calligraphy is the size of your paintbrush. Some motifs are big and bold (see right), others are fine and tapered and it is the size of the brush that creates the different effects.

Body art can be a beautiful and inexpensive alternative to jewellry, and as you can see in this case, designs do not have to be complicated to have impact.

Contemporary Eastern hand

Hand painting has been practised for centuries throughout the world. Here we've given the tradition a contemporary twist, using Indian designs to create an effect. We've used natural henna darkened with tea water to create the design below. You can expect this design to last for several weeks – natural henna and tea water is the most permanent body paint.

Right: The black henna pictured here flakes off once dry to leave a delicate orang-brown stain.

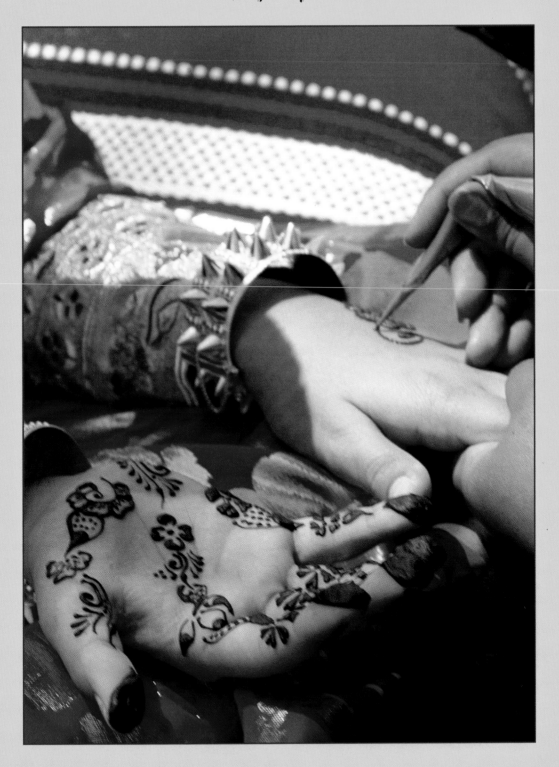

Circle of lizards

These Mexican lizards entwine to create a great belly button motif. And because they come in multi-tat stencil, they are extremely easy to do. All you need is some pre-mixed henna paste.

The belly button is a great place to decorate – evocative, sensual, and fun, it is perfect for any symmetric design. You can enhance your motif further using a button bindi and body glitter.

1 Follow all the steps for applying henna using a multi tat stencil or freehand if you are confident in your drawing skills.

Added decoration

2 To complete the effect, take a button bindi and stick it in place, taking care not to smudge the design.

Body glitter is also effective here in drawing the eye to the design and adding that extra sparkle in the evening.

The design on the right was created using a temporary transfer tattoo: again very effective, especially with the pierced belly button.

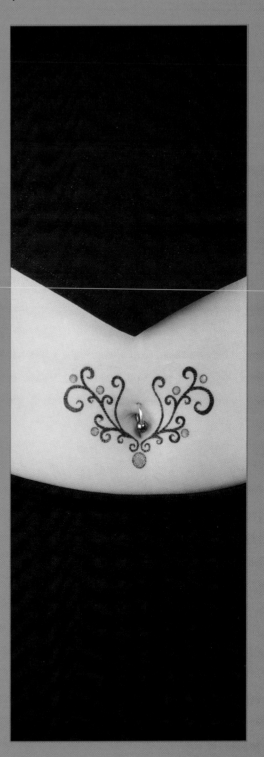

Arabian floral design

An alluring calf design based on Arabian floral designs has been created here using premixed natural henna. It has been coloured using water-based body paints. This design was created freehand and is a very loose translation.

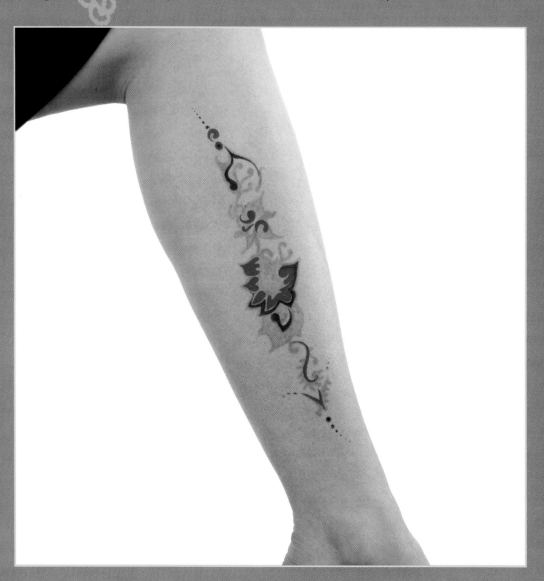

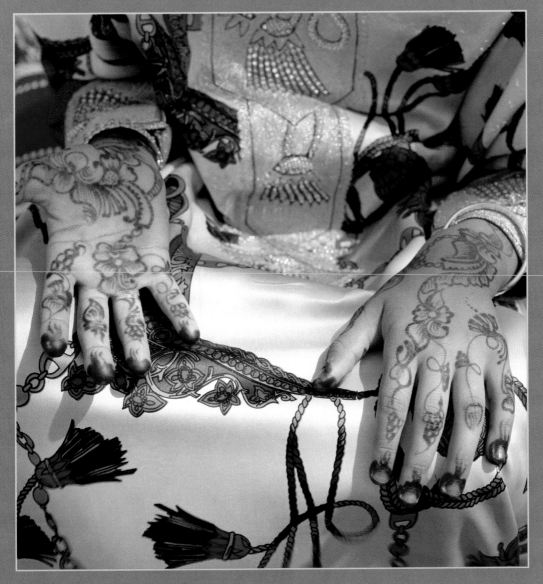

Note how we've mixed traditional floral and leaf motifs with more delicate filigree to create rhythm and a sense of flow through the design, which tapers to emphasise the length of the leg.

Above: traditional motifs and designs as seen here on this arabian bride can be adapted for a more contemporary look.

Celtic roaring dragon

A Celtic roaring dragon makes for a high-impact motif, here painted freehand on a calf muscle using pre-mixed natural henna paste and vibrant Indian body paints. This motif is definitely not for the beginner!

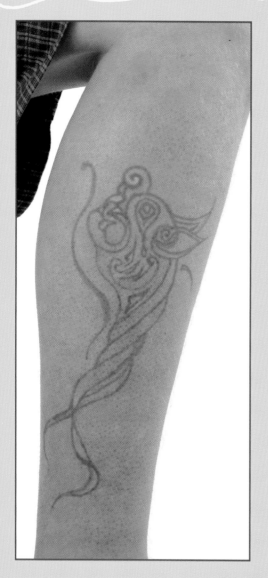

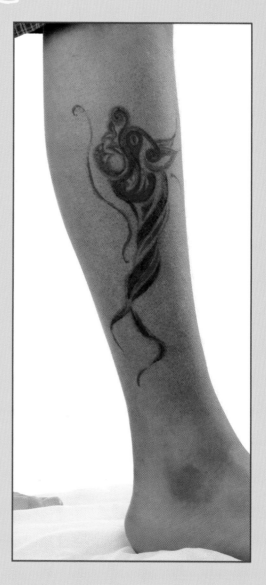

The body art portfolio

Again, draw your design out on paper beforehand. This design started out as a straight copy from an early Celtic motif but we changed it slightly to fit more sympathetically onto the area of the leg we were decorating. This is why it is important to draw out the design first, so that any alterations can be worked out beforehand with relative ease.

1 **Remember the following tips when drawing freehand designs.**

Slowly flow the henna on to the skin, as if you were icing a cake. Don't apply too much at once.

Use cotton wool swabs and toothpicks to adjust lines or remove any mistakes. Clean your applicators frequently, using cotton wool swabs. Use a needle or pin to clean the applicator nozzle if it gets blocked. Work slowly around the motif - ask the model to sit as still as possible. Control the flow of the paste by resting your hand against the skin.

2 **We used a green and red body ink to fill in the design. Green and red were a good choice for this motif and gave the effect a very striking finish.**

Carefully fill in the spaces in between the outlines, taking care not to totally cover the henna lines

New Age ankle

New Age graphics lend themselves to any number of body art designs. Ankles are a particularly good area to decorate and you can achieve some lovely effects by using the natural contours of the leg, ankle and foot to create your design

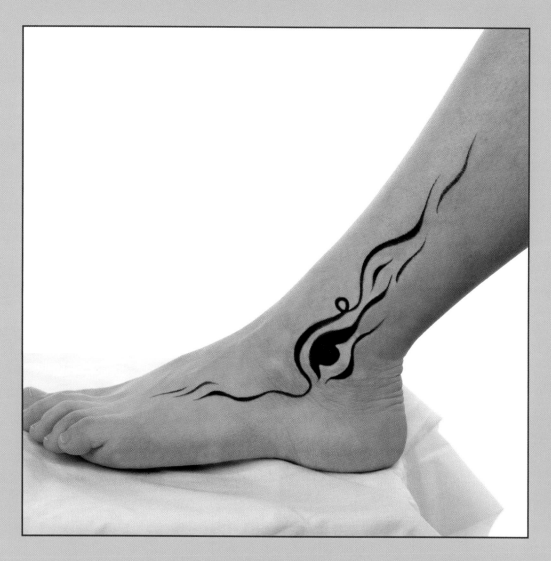

1 For this beautiful freehand design we used a pre-mixed black henna paste. This comes in a tube, but you might find it easier to transfer this to an applicator bottle and fit a nozzle with a finer hole to create the detail more accurately.

Bottles are well worth investing in if you intend doing a lot of body painting – they are easy to clean, totally reusable and very easy to handle – they are made of flexible, squeezy plastic.

When filling an applicator bottle with the paste, making sure all the air is removed. Select the correct size applicator tip and screw it firmly in place.

2 You are now ready to draw your motif. It is as well to do a few practice runs first, both with a pencil and with the henna paste on paper. Learn how the marks of the motif have been created and how different elements interlock.

If you are finding a design rather difficult to recreate, adapt it and make it simpler. Do not try anything too intricate at first – keep your lines simple.

Practice flowing the henna paste to create different thicknesses of line. Learn how to taper lines – thick one end, thin the other. These are all classic henna painting techniques.

3 Slowly flow the henna on to the skin, working slowly around the limb.

Useful information

Body Art Supply

16016 SE Division

Ste. 149, Portland,

Oregon 97236

U.S.A.

www.bodyartsupply.com

Supplier of extensive range of henna and other body art products including natural and coloured henna pastes and powders, temporary transfer tattoos, plastic and multi tat stencils and accessories to enhance your designs – take a look at their website it contains an online catalogue with their full range of products.

Mehndi Body Art/the Bomb Factory

2501 E. 28th Street

Suite 118

Signal Hill

California

www.mehndibodyart.com

Supplier of henna and other temporary body art products. Also has an internet body art gallery

Mehndi Madness

2211 NW Market Street

Seattle

WA 206 782 7314

Established henna and Mehndi stockist. Internet web page includes gallery, designs and kits as well as interactive classes.

Useful information

Marsh Morgan

Ash Hill Court

Ash Hill Road

Torquay

Devon

TQ1 3JD

www.webtribe.net

Innovative body artist with internet body art gallery page. Also a supplier of body art materials

Halawa henna

ESS House

94-6 Chapel Street

Leigh

Lancashire

www.halawahenna.demon.co.uk

Supplier of henna body art products. Also has gallery page on Internet with more traditional bias.

Many high street store supply body art products so check out your local stores for easy access. Remember to always read the packaging and instructions that come with the products. Check the ingredients listing on the products – if it doesn't have one don't buy it! Always patch test products on your skin before going ahead with a design and if you have any allergic reaction at all don't use it.

Index

Index

H

hand
 painting 6, 7, 13, 14-15, 19, 54, 82-83, 87

henna
 facts 54
 paste 47, 48
 powder 47
 recipes for paste 48-49

I

India
 henna traditions 6, 10, 12, 13, 44
Internet
 body art sources and stockists 9, 92-93

L

lemon and sugar solution
 uses 50, 52

M

mehndi oil
 uses 48, 5-52
Middle East
 henna traditions 6, 10, 18, 44, 64, 87
multi-tat
 stencils 67, 68, 73, 80

N

natural henna 47, 48, 51, 54, 74
neck
 painting 54

O

olive oil
 uses 50

P

pre-mixed coloured henna paster 48, 50, 67
pre-mixed natural henna paster 48, 50, 61, 76, 82, 86-87

R

rose water
 uses 51

S

shoulder
 painting 72, 73
stencils
 doit-yourself and/or plastic 51, 75
sundries
 for henna painting 50
 for body paint 56

T

tea
 uses in henna painting 48, 49, 74
temporary tattoos 59, 64, 66
traditional body painting styles 7, 83, 87
transfers 59, 64, 65, 66, 85

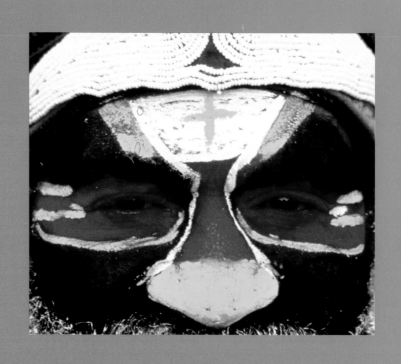